CELTIC DESIGNS COLORING BOOK

CAROL SCHMIDT

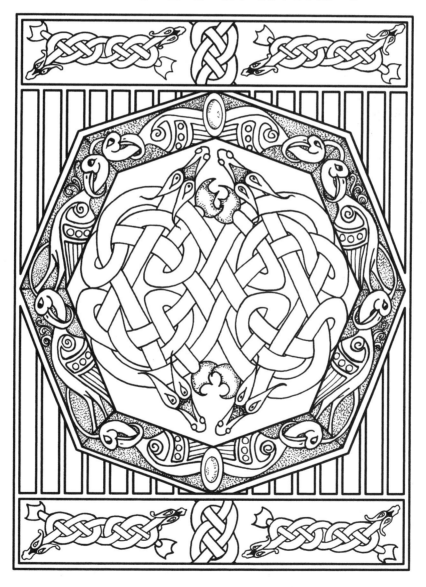

DOVER PUBLICATIONS, INC.
MINEOLA, NEW YORK

Re-create the glories of Celtic art with this coloring collection featuring animal, geometric, and nature motifs, alphabet designs inspired by the celebrated illuminated manuscripts, and mandala patterns, all of which include the recognizable Celtic interlace—the looped, braided, and knotted "bands" that are almost always used for filling in borders and empty spaces in Celtic art. The detailed nature of the designs makes this collection perfect for Dover's Creative Haven series for the experienced colorist. The patterns are an ideal template for experimentation with different color and media techniques, plus the perforated, unbacked pages make displaying finished work easy.

Bibliographical Note

Celtic Designs Coloring Book is a new work,
first published by Dover Publications, Inc., in 2015.

International Standard Book Number

ISBN-13: 978-0-486-80310-4
ISBN-10: 0-486-80310-4

Manufactured in the United States by RR Donnelley
80310403 2016
www.doverpublications.com

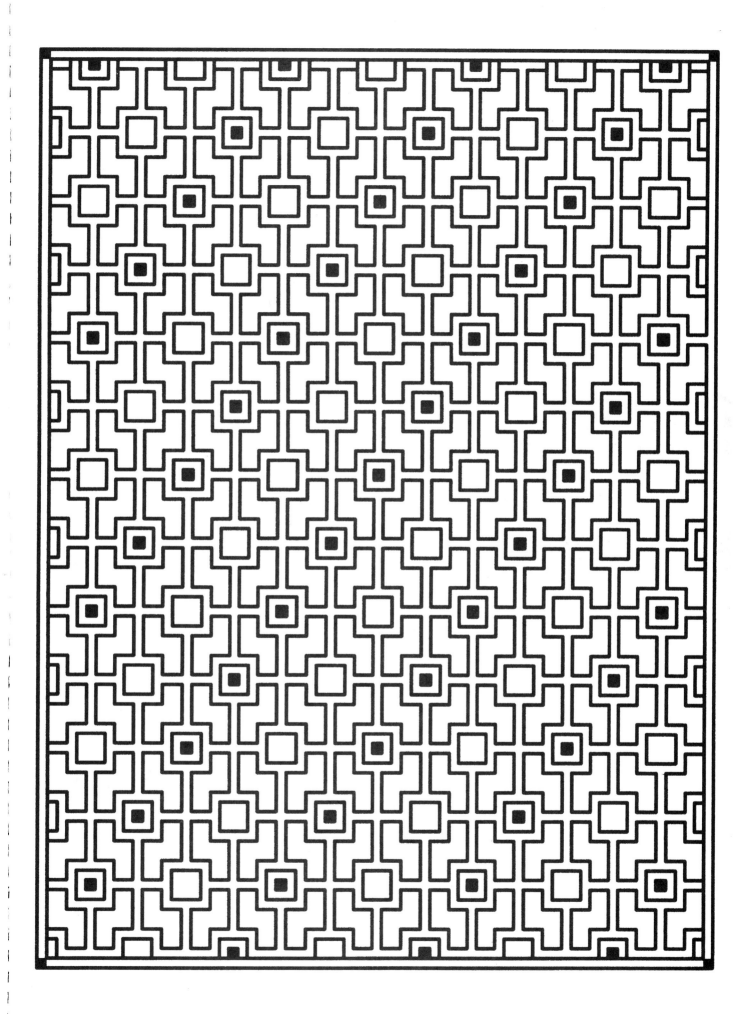

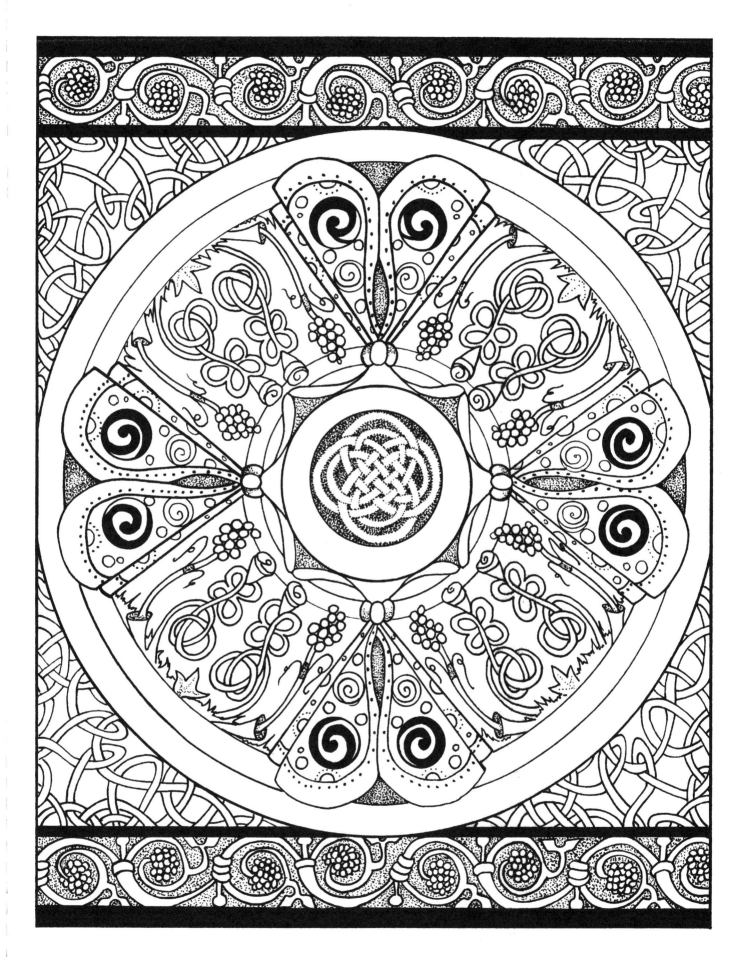

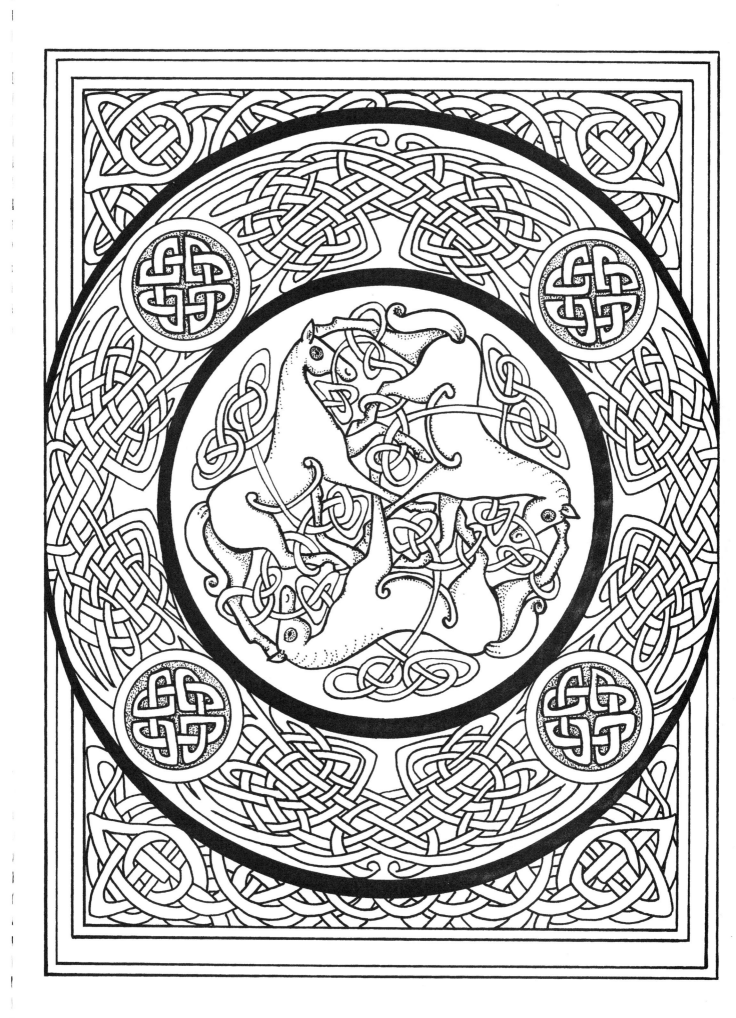

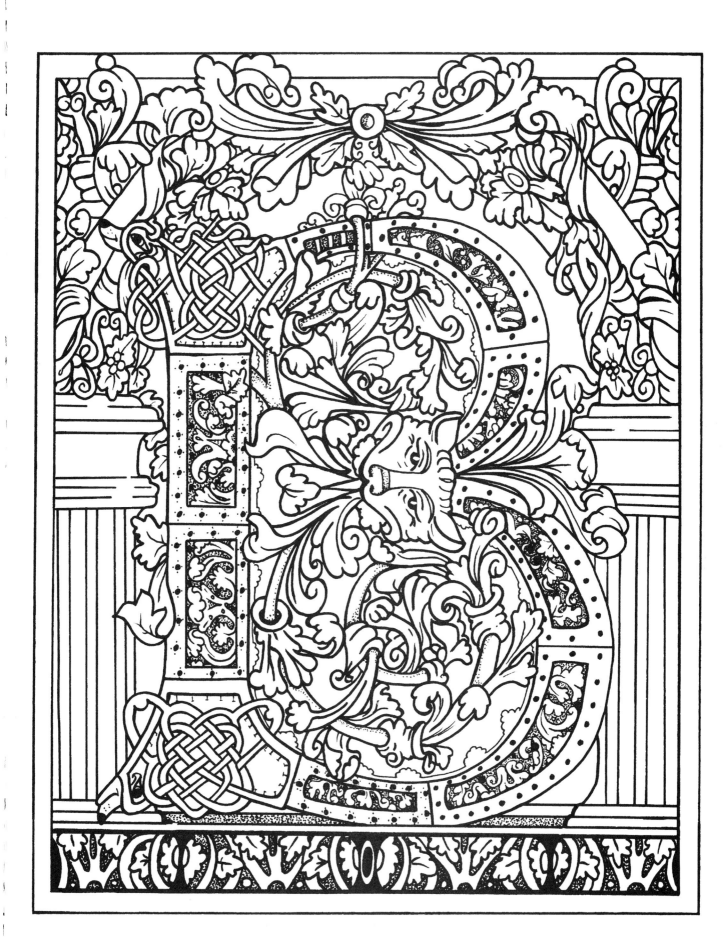

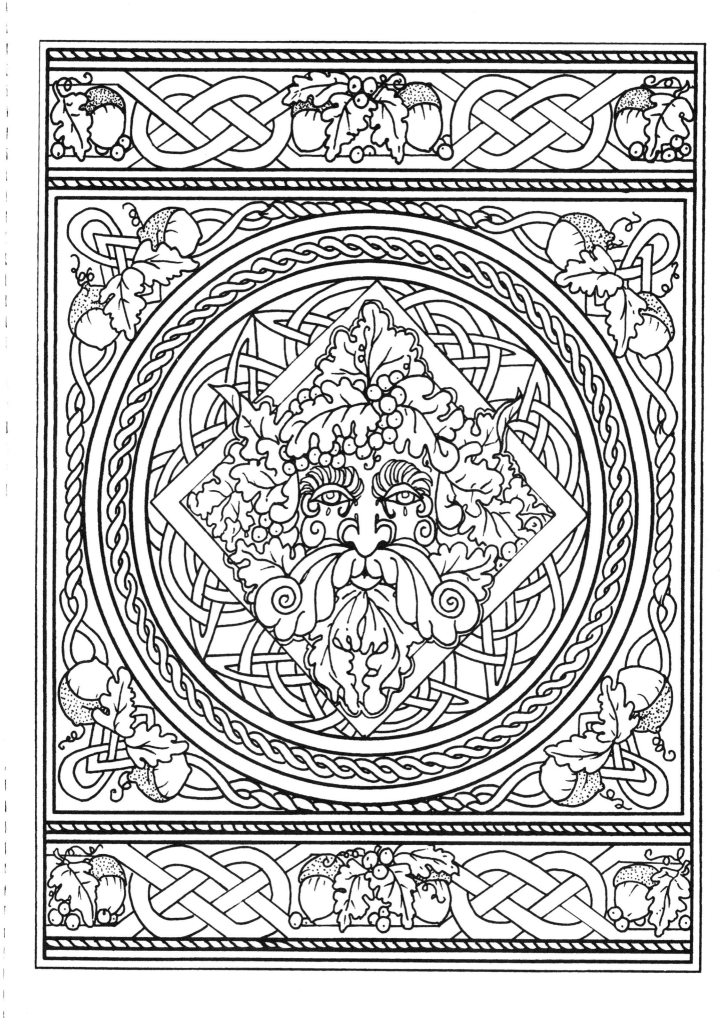

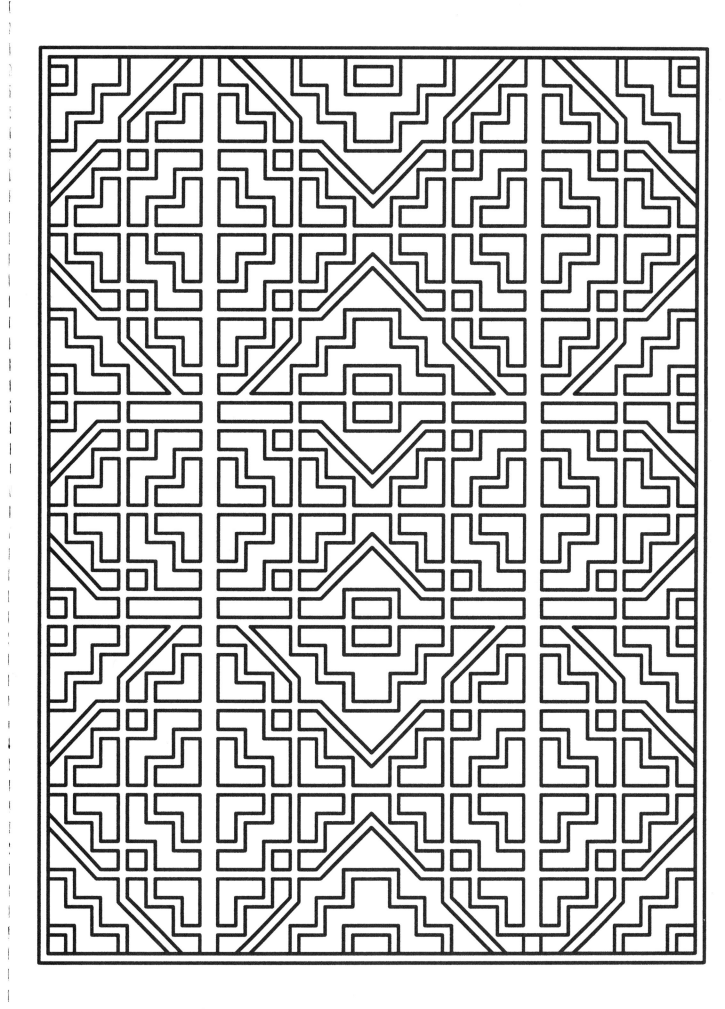

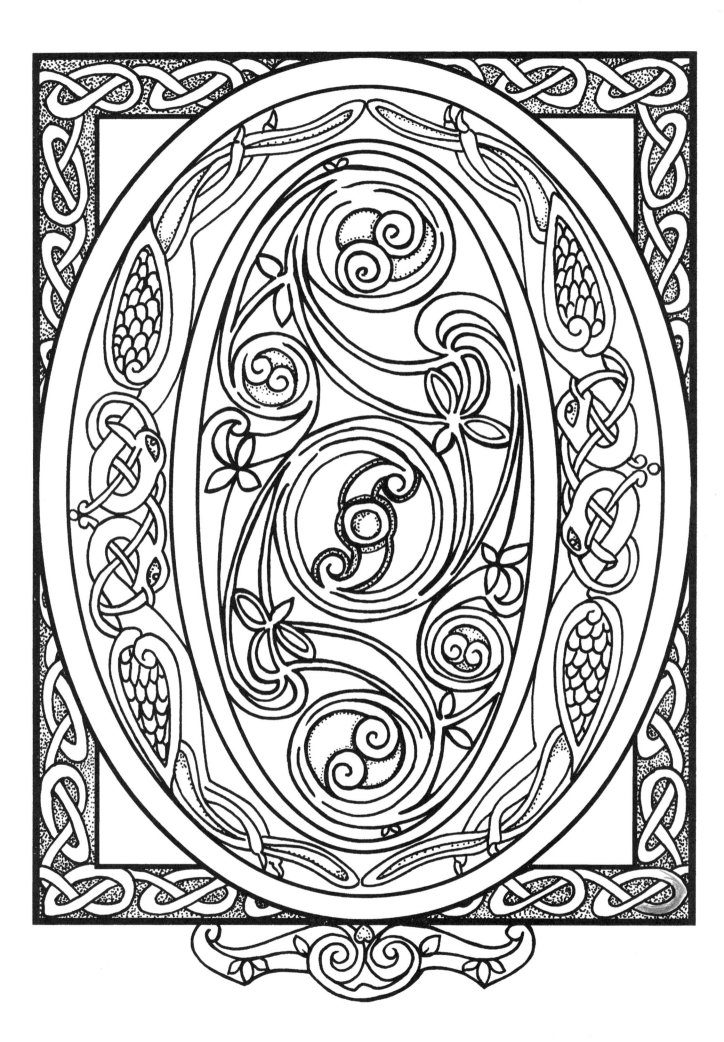

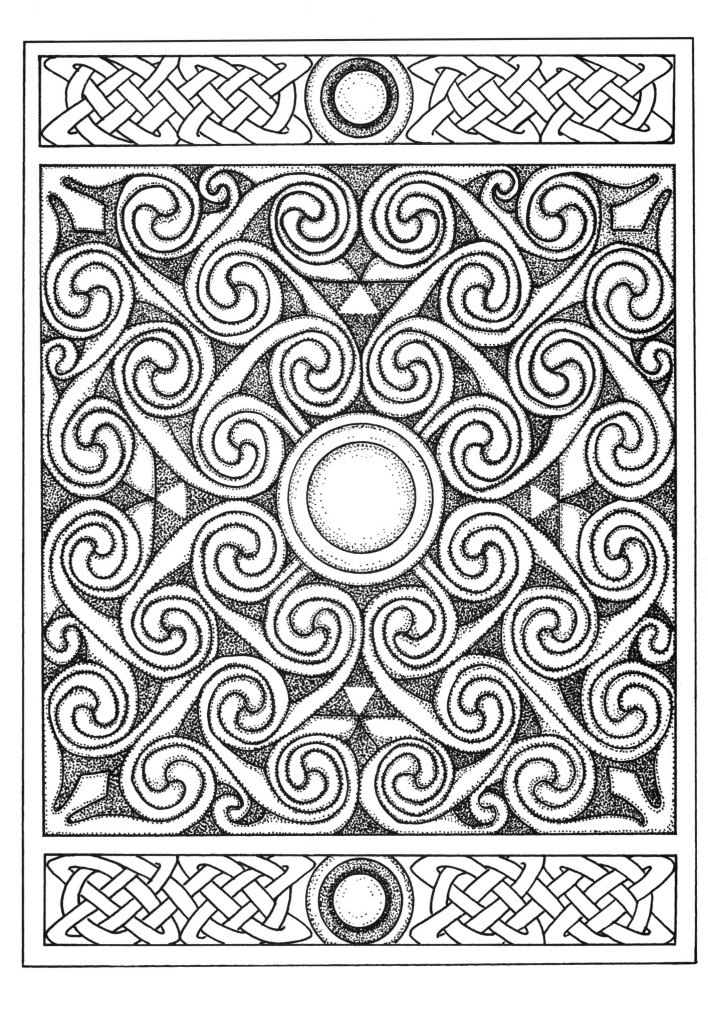

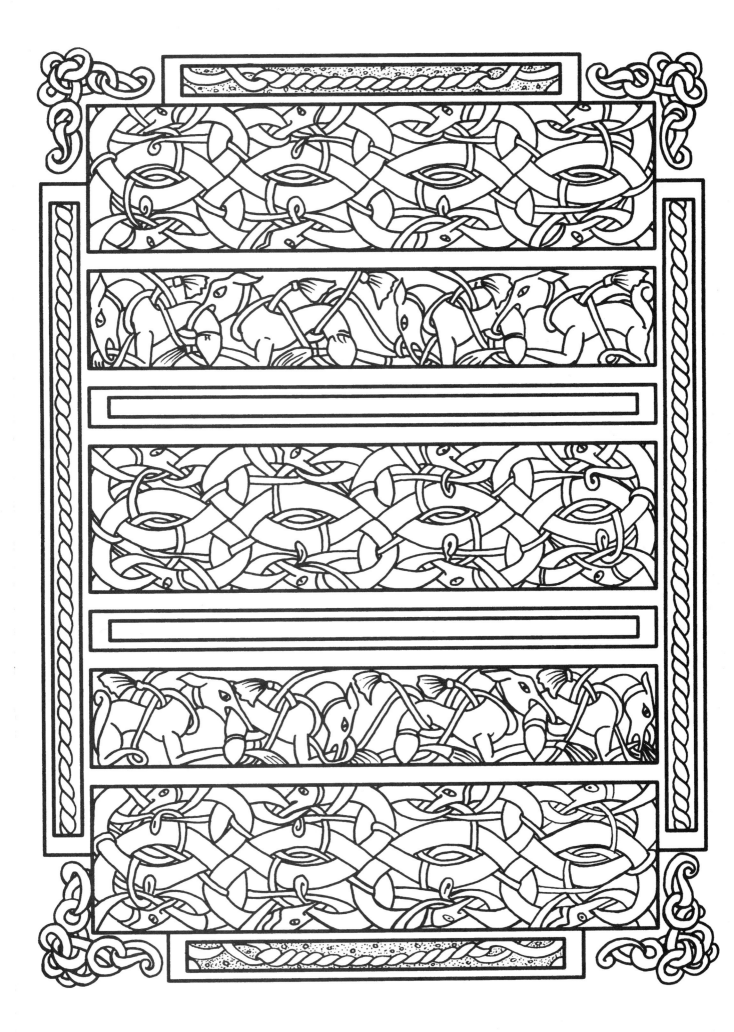

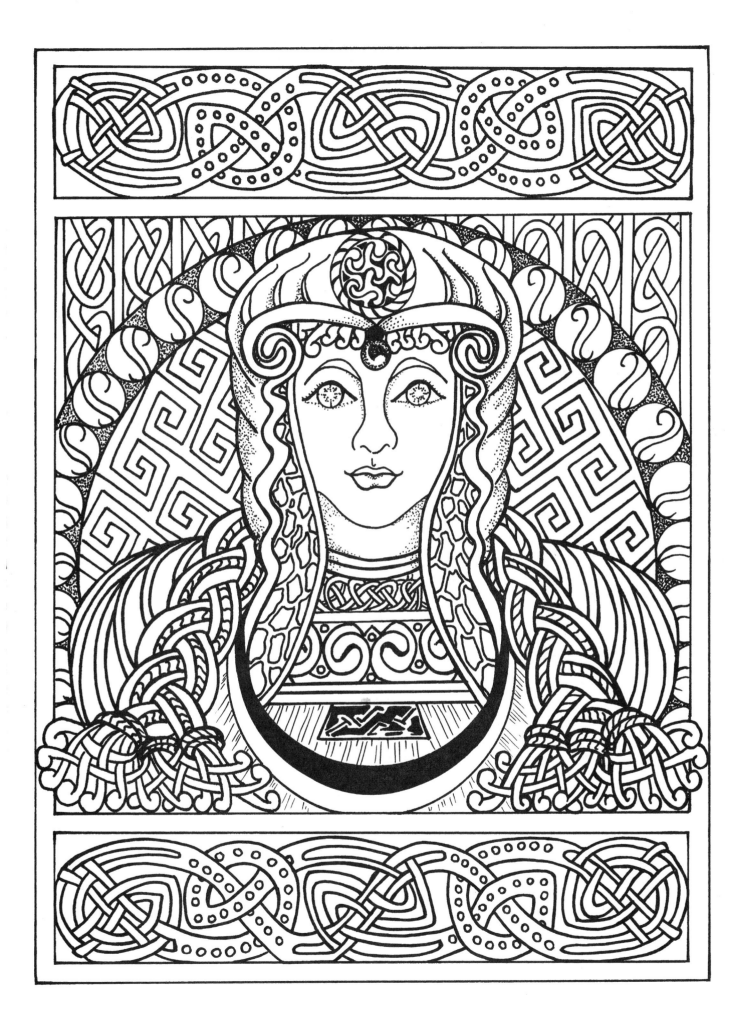

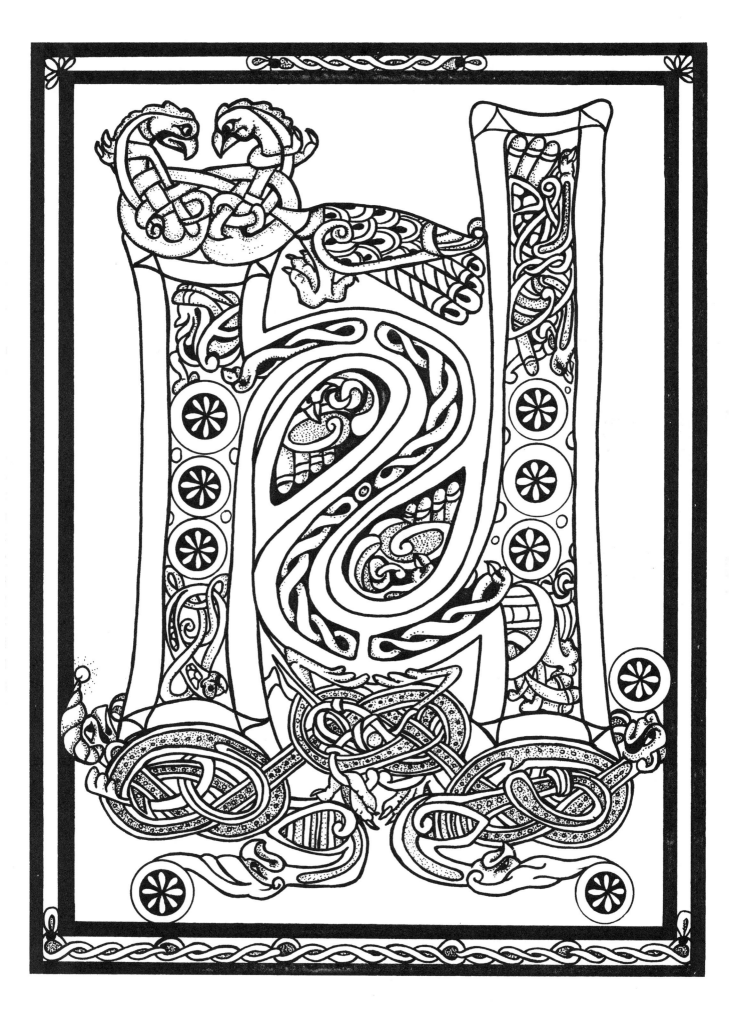

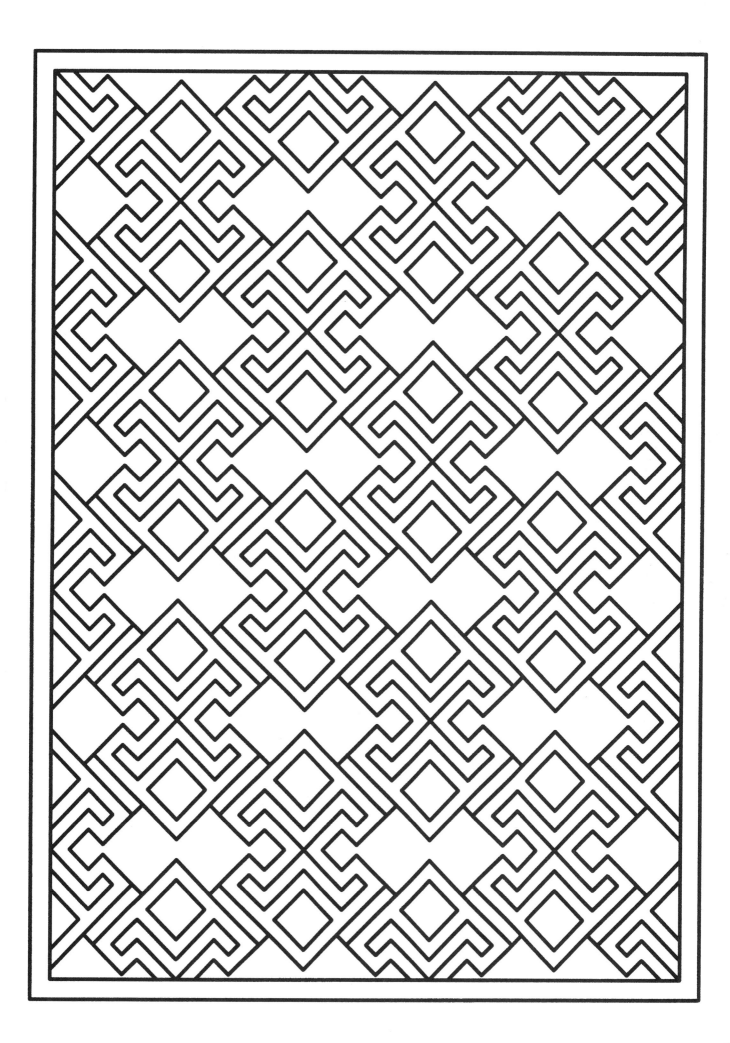

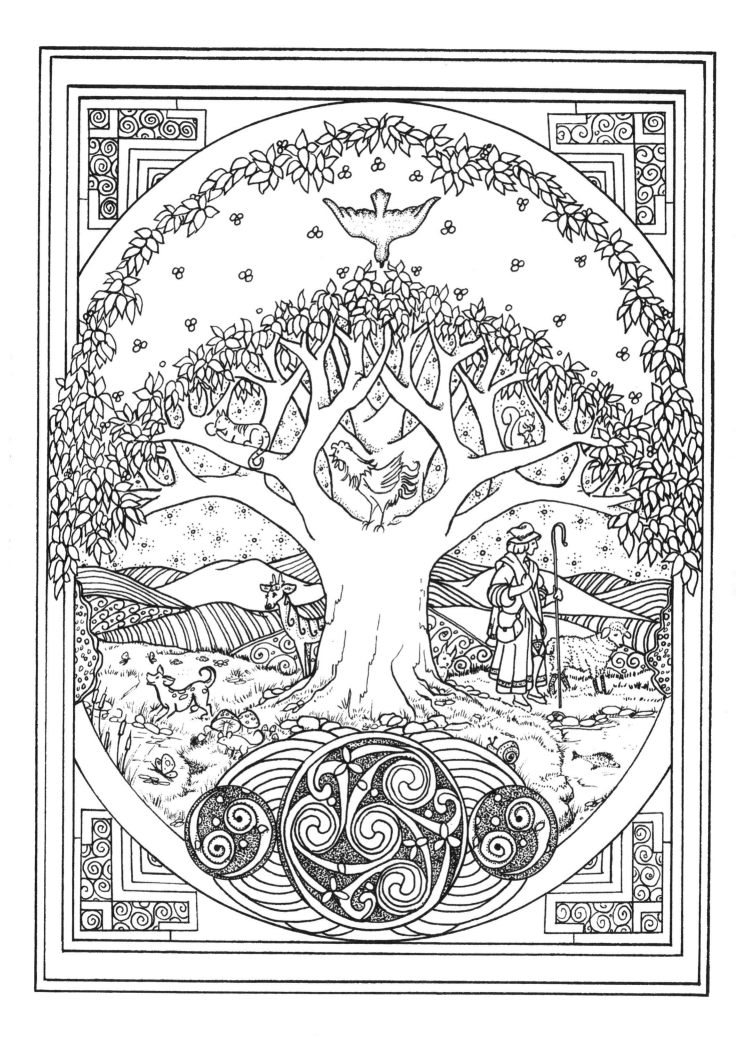

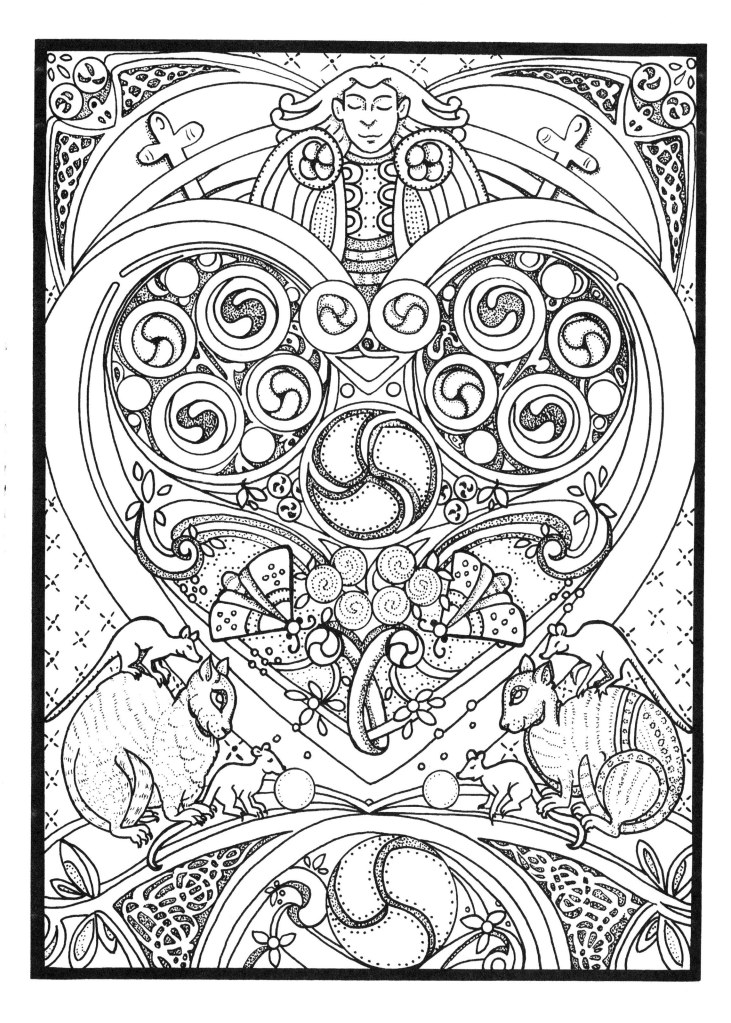

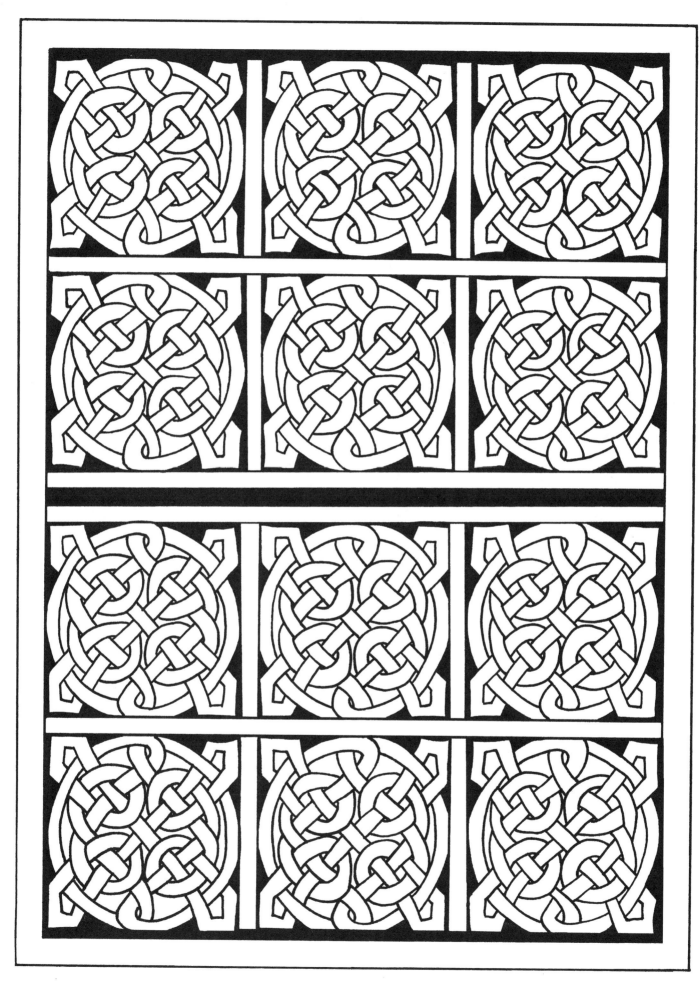

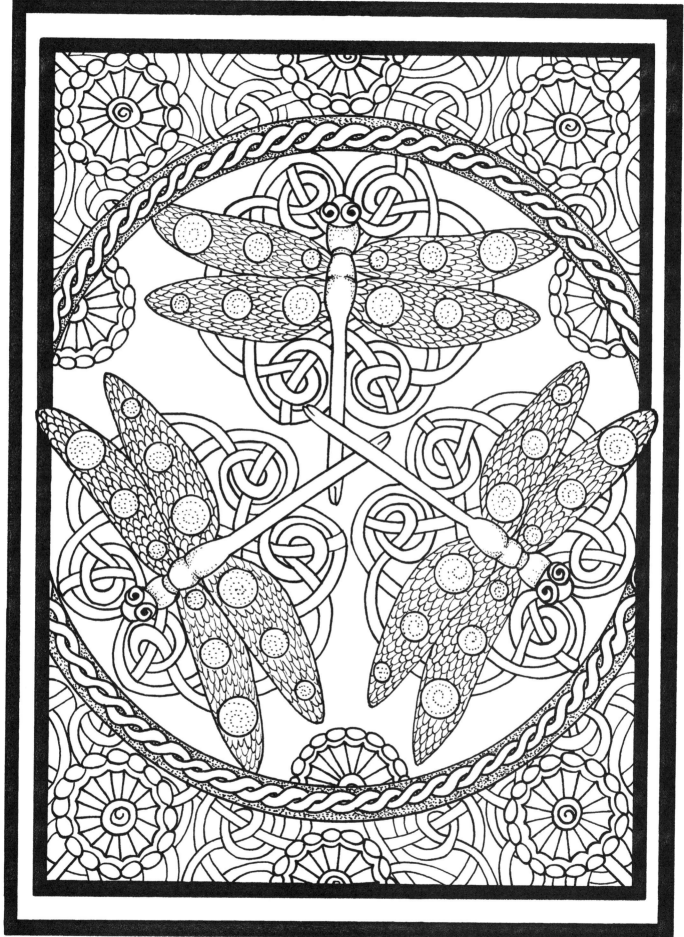

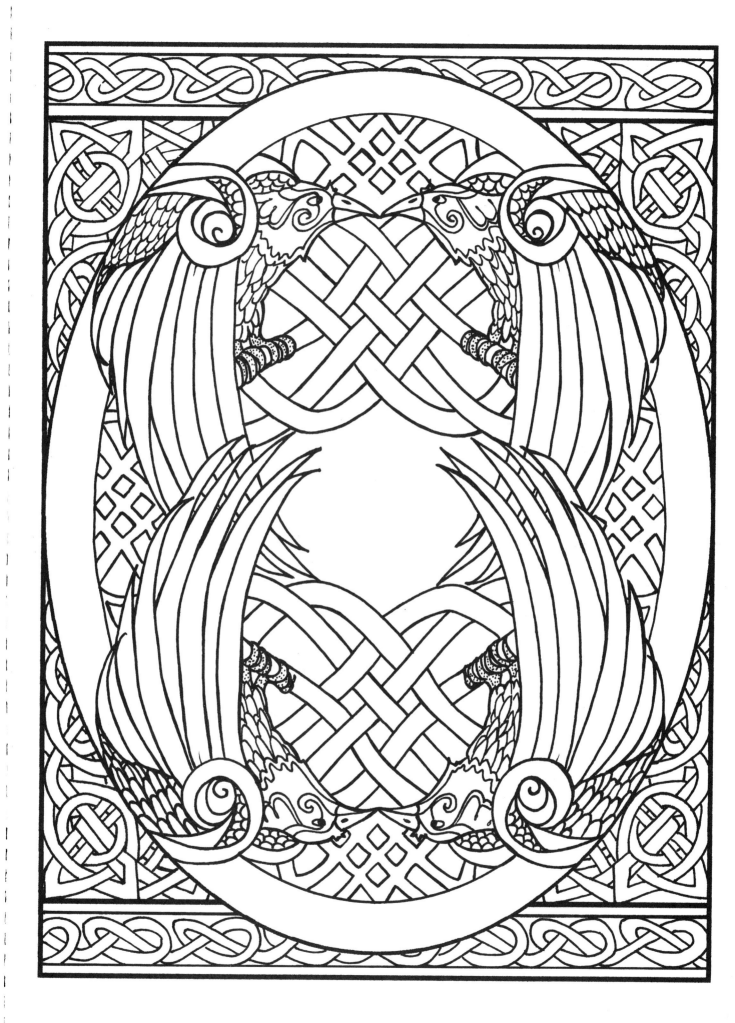

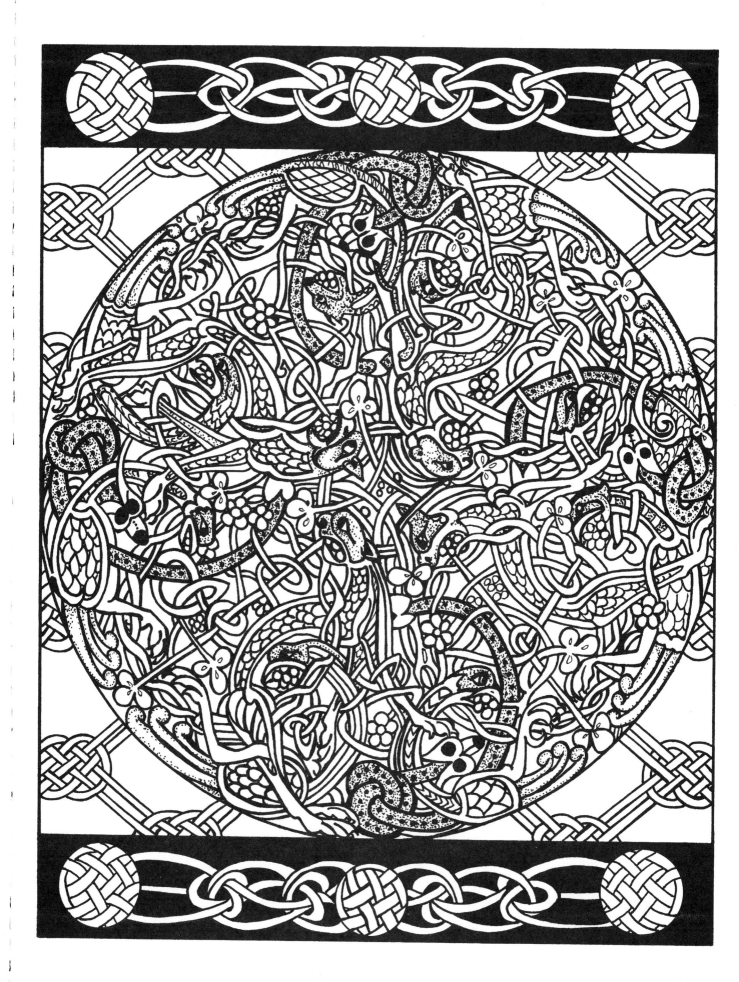

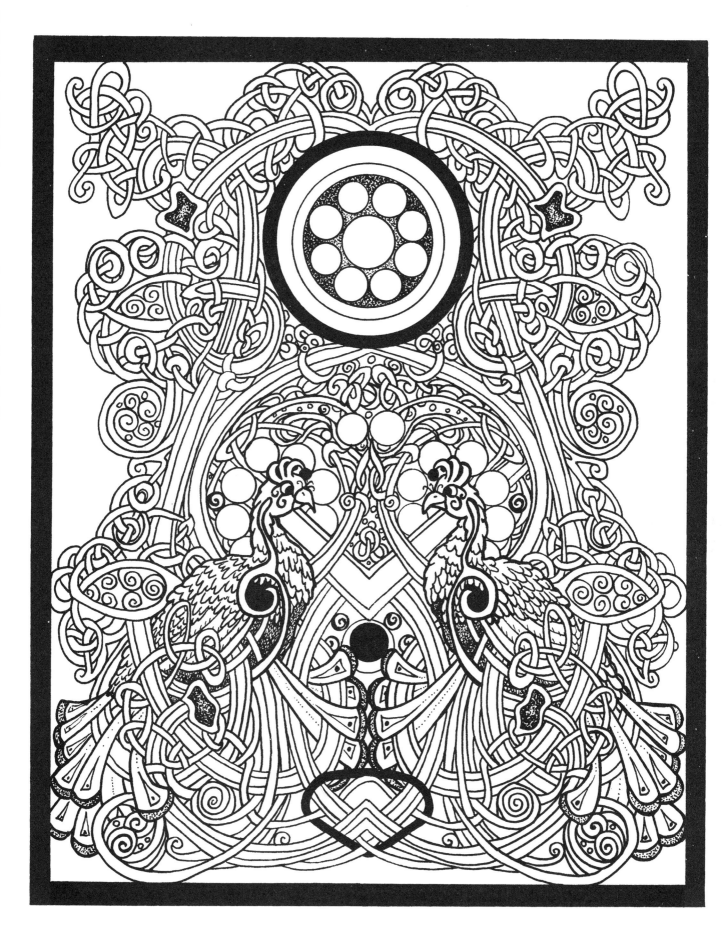

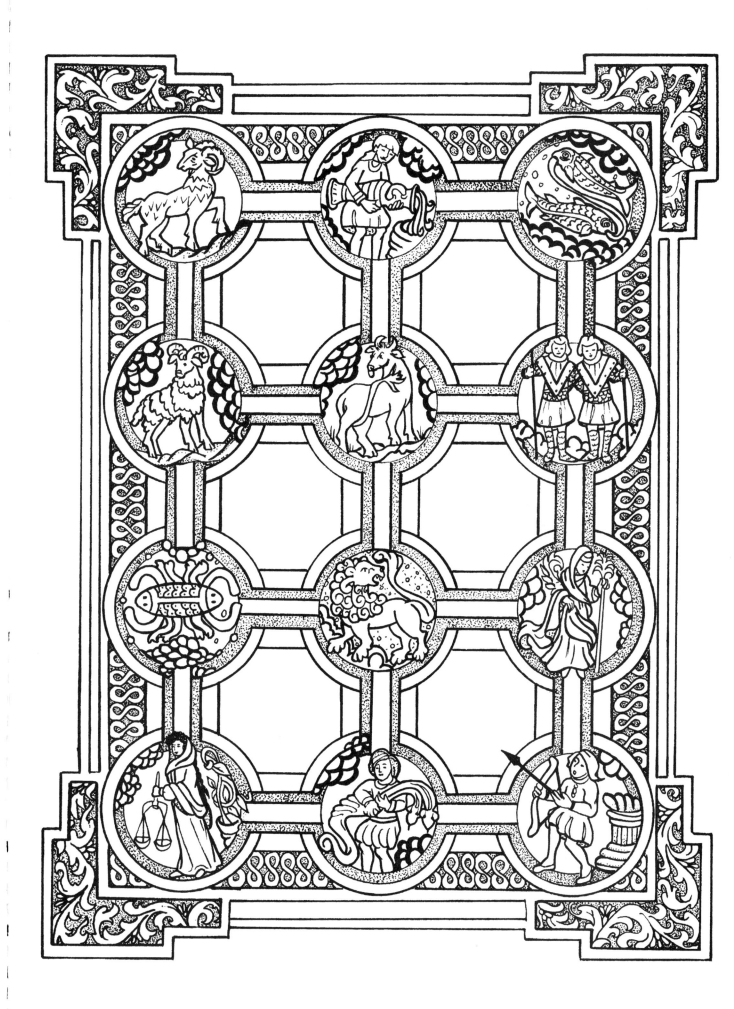

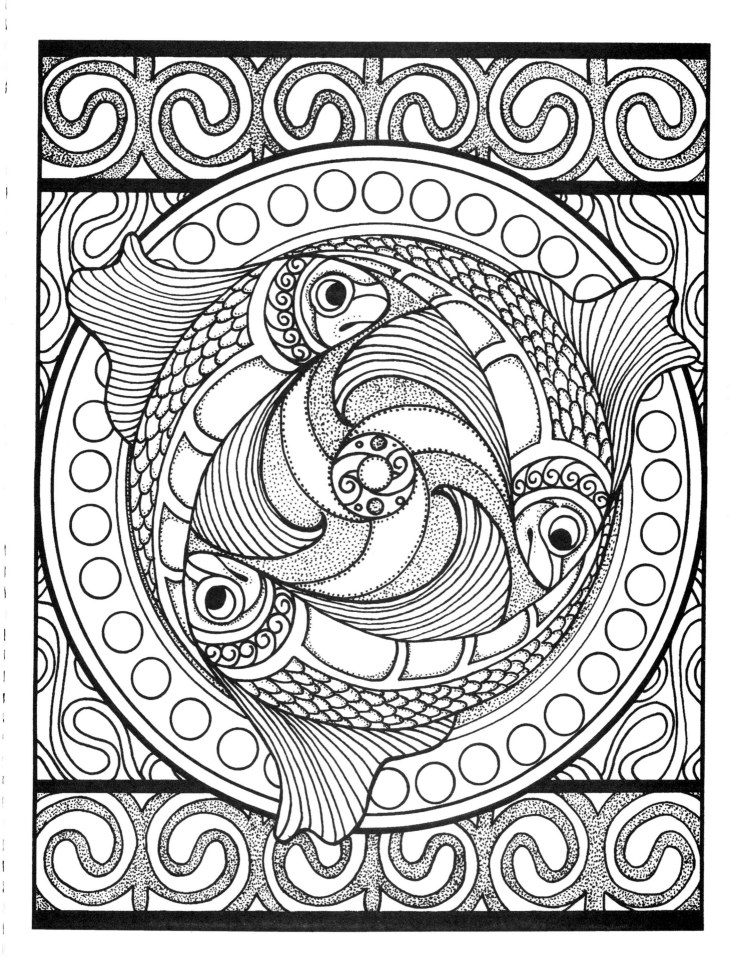

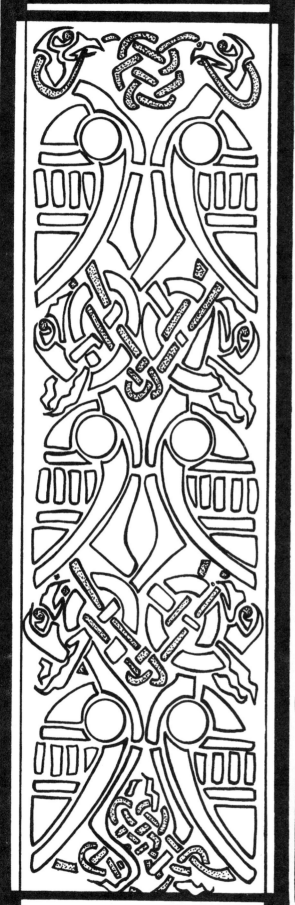
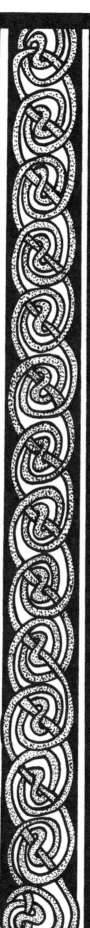
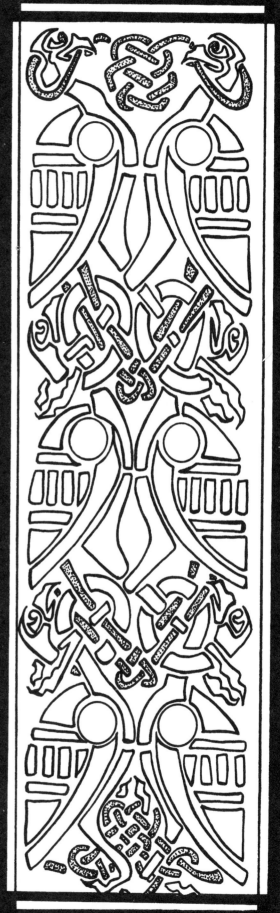

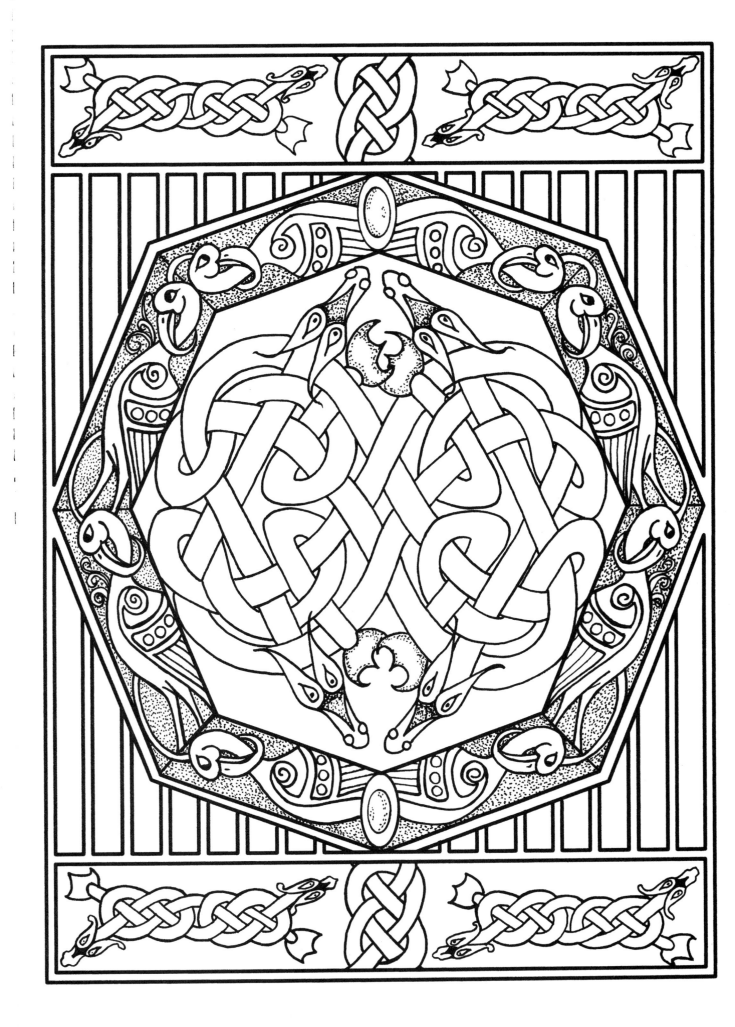

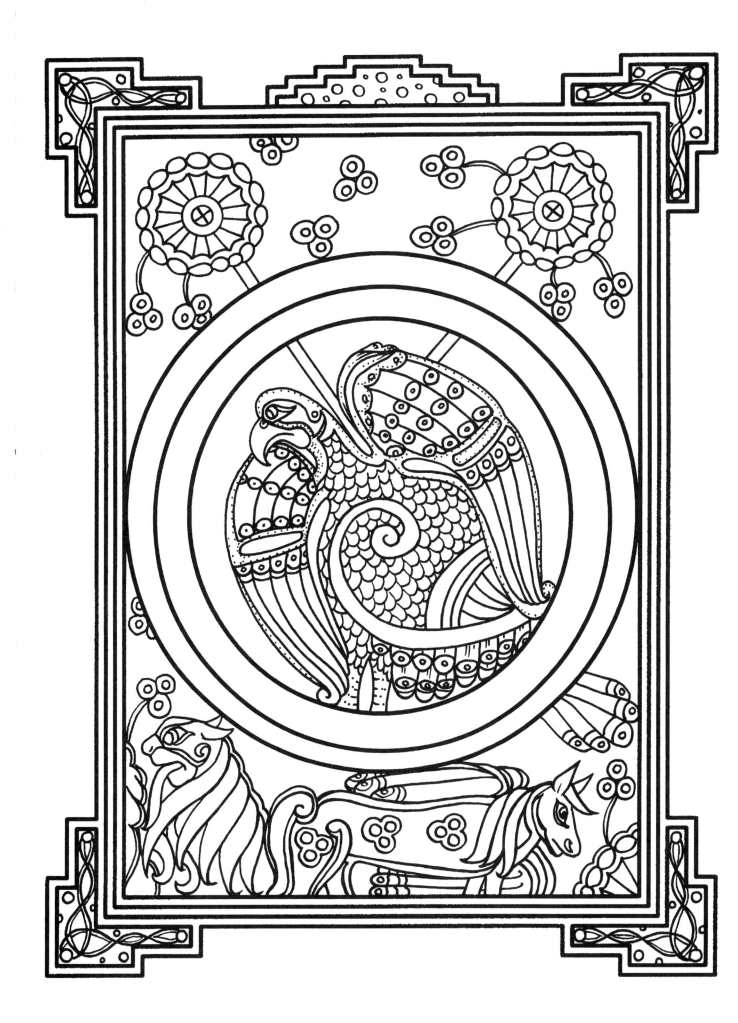

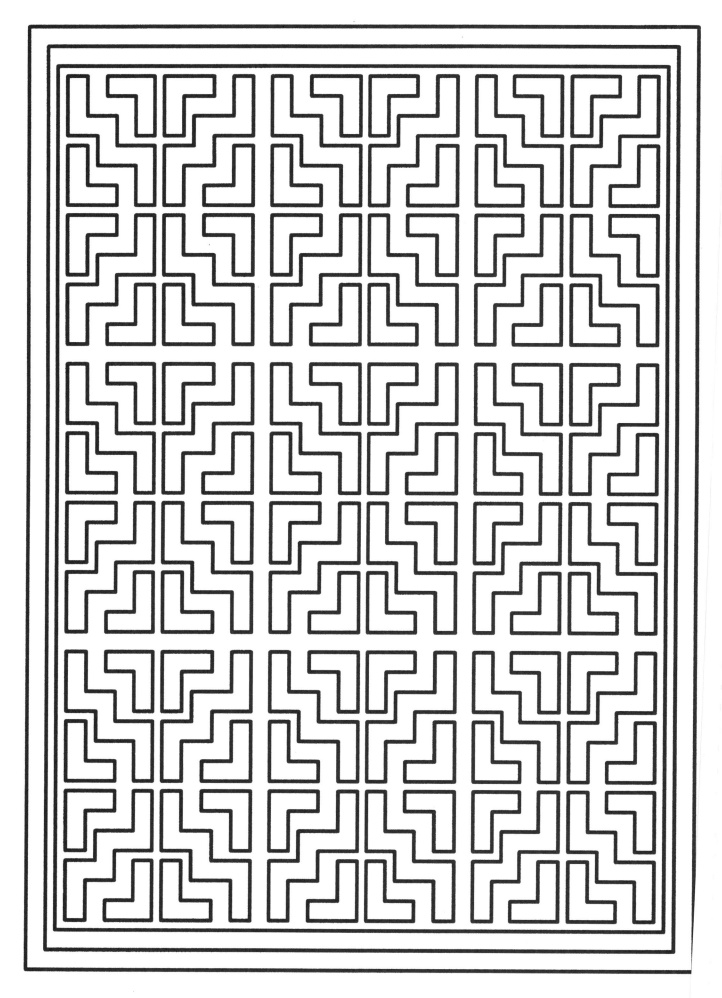

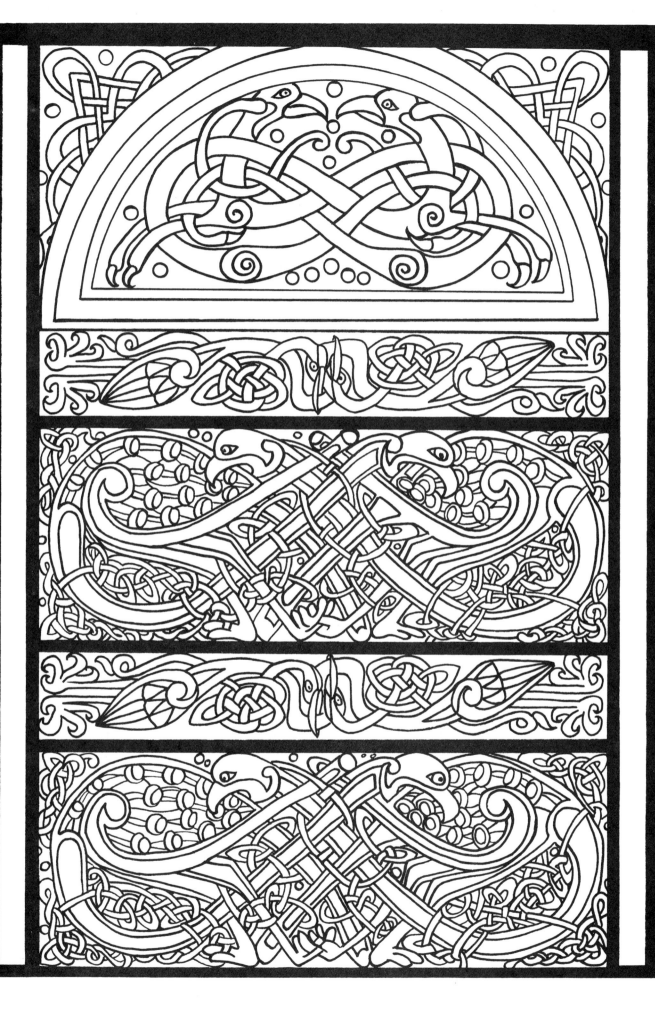

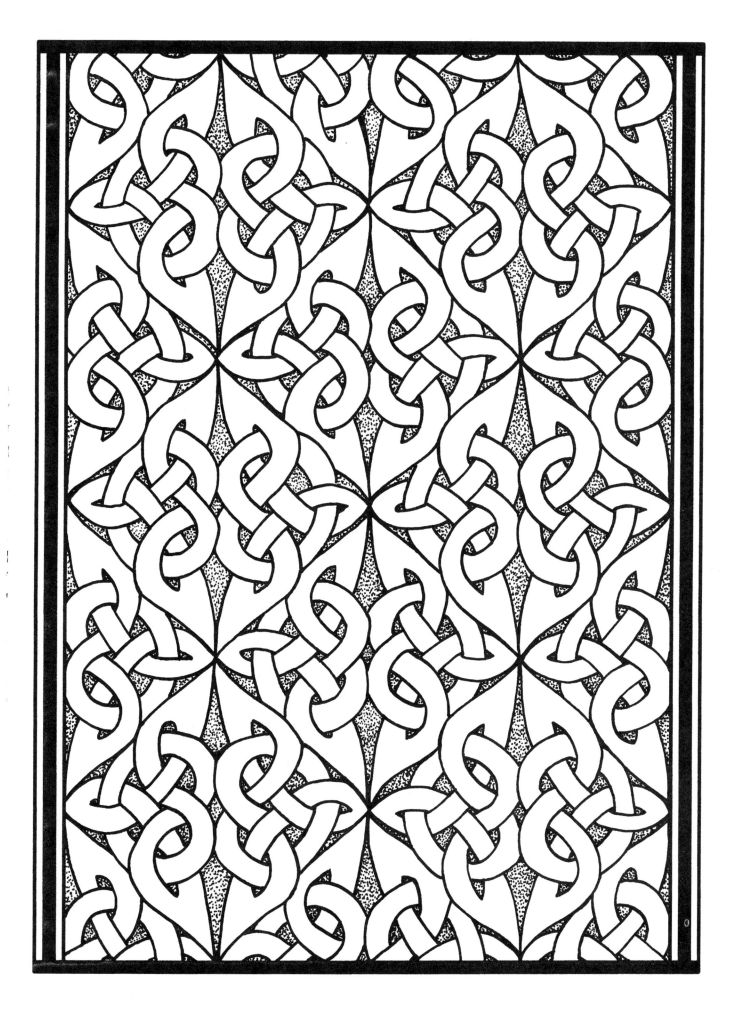

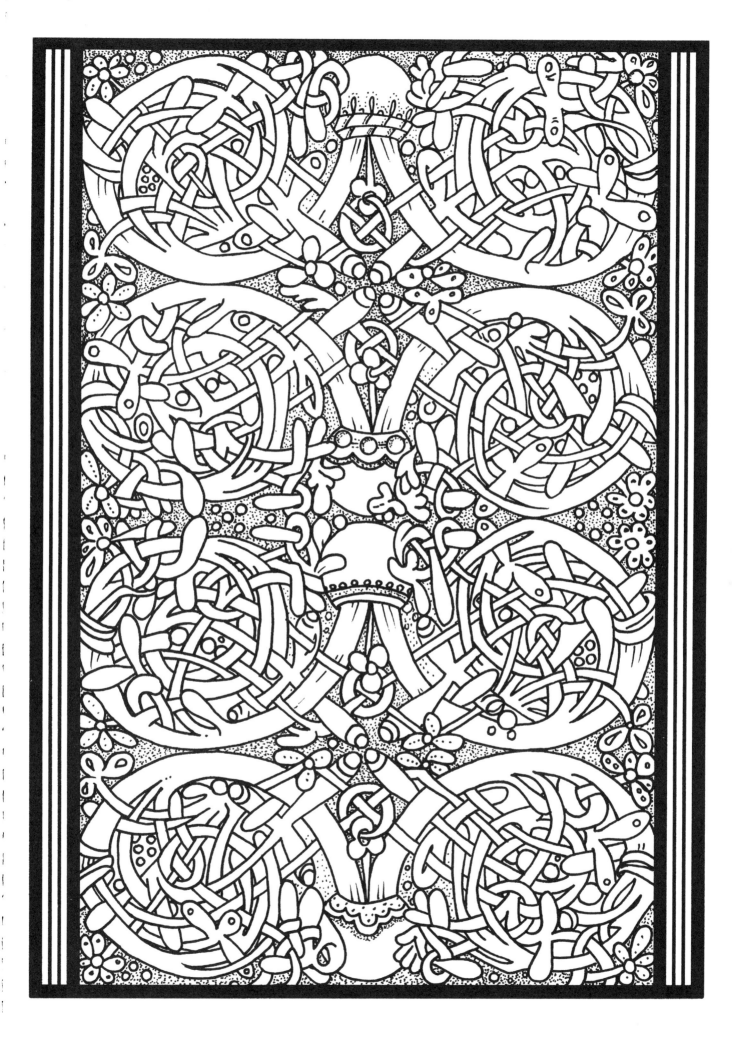